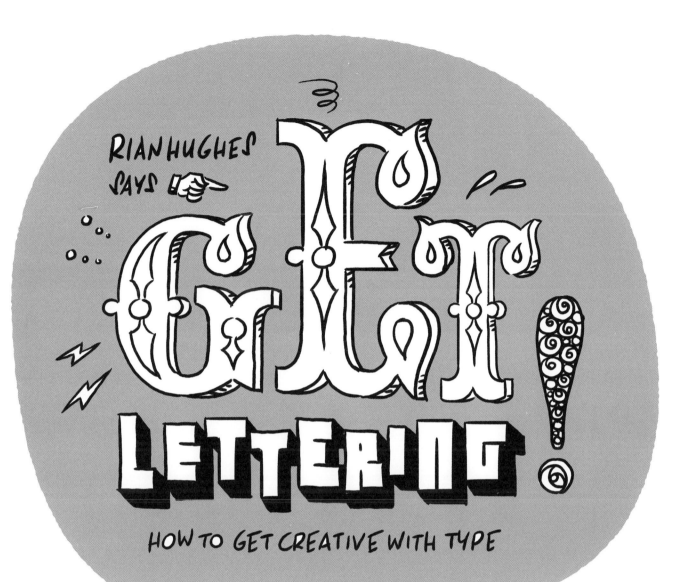

RIANHUGHES SAYS

GET LETTERING!

HOW TO GET CREATIVE WITH TYPE

kinkajou

GET LETTERING

PUBLISHED BY KINKAJOU

A CATALOGUE RECORD FOR THIS BOOK IS AVAILABLE FROM THE BRITISH LIBRARY.

KINKAJOU IS AN IMPRINT OF FRANCES LINCOLN LIMITED
74-77 WHITE LION STREET
LONDON N1 9PF
WWW.KINKAJOU.COM

ISBN: 978-0-7112-3761-2

PRINTED IN CHINA

9 8 7 6 5 4 3 2 1

CONTENTS

GRAB A PEN OR A BRUSH — OR EVEN AN INKY STICK, AND PREPARE TO EXPLORE THE UNIVERSE OF LETTERING.

MASTER DIFFERENT STYLES AND EFFECTS, EXPLORE DECORATIVE AND FANCY TYPE, DESIGN SIGNS AND POSTERS, AND LOOK OUT FOR ALL KINDS OF INSPIRATIONAL LETTERING AROUND YOU.

WITH A LITTLE PRACTICE, YOU'LL BE A MASTER TYPOGRAPHER IN NO TIME.

SO — GET LETTERING!

1 CHOOSE YOUR TOOLS

PEN OR PENCIL? CRAYON OR BRUSH? WHICH TOOL SHOULD YOU USE?

THERE IS NO RIGHT OR WRONG ANSWER — EACH WILL ALLOW YOU TO DRAW LETTERS IN A DIFFERENT STYLE.

LETTERING DRAWN WITH A BRUSH IS CALLED 'CALLIGRAPHY'. LETTERING DRAWN WITH A SPRAY PAINT CAN IS CALLED 'GRAFFITI'. LETTERING DRAWN WITH AN INKY STICK IS CALLED 'MESSY LETTERING DRAWN WITH AN INKY STICK'.

FELT PEN

Pencil

ROUGH BRUSH

CRAYON

MARKER PEN

INKY STICK

Fat Pen

THIN PEN

BRUSH

Biro

TRY USING DIFFERENT TOOLS TO DRAW SOME LETTERS HERE: DATE:

2 Your Signature

EVERY GREAT ARTIST HAS A UNIQUE SIGNATURE.

SO BEFORE WE JUMP RIGHT IN, YOU NEED TO DESIGN YOUR OWN SIGNATURE. YOU CAN THEN USE THIS TO SIGN ALL YOUR WORK, SO THAT FUTURE GENERATIONS WILL RECOGNISE YOUR GENIUS.

TO LOOSEN UP YOUR DRAWING HAND, BEGIN BY CREATING SIGNATURES FOR THE IMAGINARY FAMOUS PEOPLE BELOW.

A GOOD SIGNATURE WILL HAVE THE SAME KIND OF CHARACTER AS THE PERSON IT BELONGS TO.

HARRY HOUDINI, ESCAPE ARTIST

VIRGINIA WOOLF, WRITER

WOLFGANG AMADEUS MOZART, COMPOSER

HENRI MATISSE, ARTIST

QUEEN ELISABETH I, QUEEN OF ENGLAND

EDGAR ALLAN POE, WRITER

BARACK OBAMA, PRESIDENT

HEY PRESTO, MAGICIAN

CHUCK MANLY, SUPERSONIC JET PILOT

JUNE SEPTEMBER, JAZZ SINGER

HARRY HIGGINBOTTOM, COMPUTER SCIENTIST

FAIRLANE MARMADUKE, SPY

MADELEINE MINCEPIE, CHEF

ALICE MACKEREL, SHIP CAPTAIN

NOW DESIGN YOUR OWN SIGNATURE! TRY SEVERAL STYLES WITH
DIFFERENT PENS AND CHOOSE THE ONE YOU LIKE THE BEST.

DATE: []

TICK THE BOX ABOVE YOUR CHOSEN SIGNATURE: ☐ ☐

☐ ☐

☐ ☐

☐ ☐

☐ ☐

☐ ☐

☐ ☐

3 MONOGRAMS

A MONOGRAM IS A NEAT DESIGN MADE FROM A COMBINATION OF YOUR INITIALS.

DESIGN YOUR OWN, THEN USE IT TO PERSONALISE YOUR BOOKS, BAGS AND THE GATES TO YOUR MANSION!

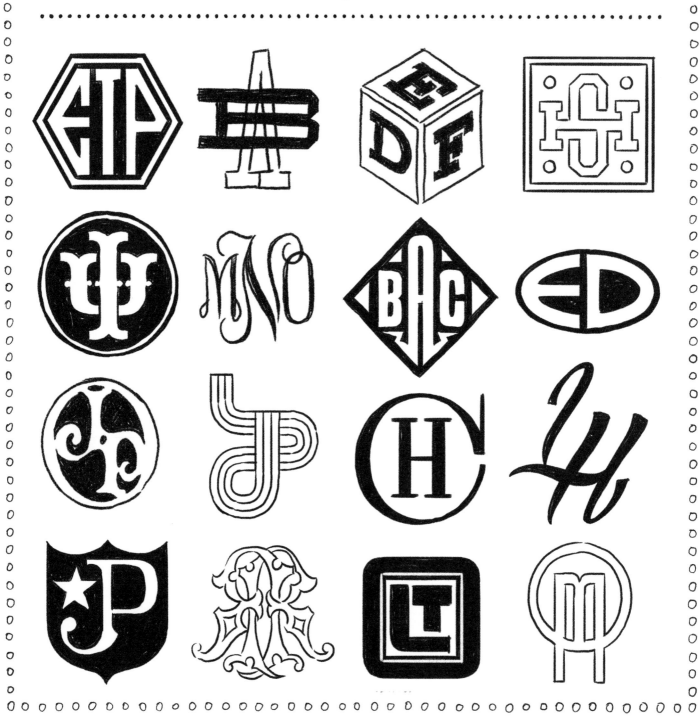

TRY YOUR INITIALS WITHIN THESE MONOGRAM SHAPES, OR JUST AS INTERLINKED LETTERS WITHOUT A FRAME:

DATE:

4 LETTERING STYLES: SANS

LETTERING COMES IN MANY DIFFERENT STYLES. SOME ARE FANCIFUL, SOME ARE SIMPLE. SOME ARE BOLD AND SOME ARE LIGHT. SOME ARE TALL AND SOME ARE WIDE. SOME ARE TRADITIONAL AND SOME ARE MODERN. SOME YOU CAN READ, AND SOME YOU CAN'T.

SHOWN ON THE NEXT FEW PAGES ARE SOME OF THE BASIC STYLES THAT LETTERING CAN BE DRAWN IN. THIS IS THE SIMPLEST, THE 'SANS SERIF' STYLE, OR 'SANS' FOR SHORT. 'SANS' IS FRENCH FOR WITHOUT. FIND OUT WHAT A 'SERIF' IS ON THE NEXT PAGE.

ABCDEFGHIJKL
MNOPQRSTUVW
,&!?XYZ$£€.
abcdefghijklm
nopqrstuvwxyz
1234567890
Light Medium **Bold**

SANS

ABCDEFGHIJKL
MNOPQRSTUVW
, & ! ? XYZ $ £ € .
abcdefghijklm
nopqrstuvwxyz
1234567890

Light Medium **Bold**

NEXT WE COME TO THE 'SERIF', WHICH HAS 'FEET' AT THE ENDS. SOMETIMES IT HAS A ROUND BALL INSTEAD, WHICH IS CALLED A 'BALL SERIF'. IN THIS STYLE, THE HORIZONTAL PARTS OF THE LETTERS ARE OFTEN THINNER THAN THE VERTICAL PARTS.

IN THE LOWER CASE, LETTERS OFTEN HAVE SERIFS AT THE TOP THAT ONLY STICK OUT TO THE LEFT. THE 'a' AND THE 'g' CAN HAVE TWO STOREYS OR ONE. THE ITALIC HAS CURLY SERIFS THAT LOOK A BIT LIKE HANDWRITING.

ABCDEFGHIJKL
MNOPQRSTUVW
, & ! ? XYZ $ £ € .
aabcdefgghijklm
nopqrstuvwxyz
1234567890

Light **Medium** **Bold**

PRACTICE TRACING THE STYLES OF LETTERING SHOWN HERE: DATE: []

SERIF

ABCDEFGHIJKL
MNOPQRSTUVW
, & ! ? XYZ $ £ € .

aabcdefgghijklm
nopqrstuvwxyz
1234567890
Light Medium Bold

6 Lettering Styles: Script

SCRIPT STYLES LOOK A BIT LIKE HANDWRITING. THE LETTERS CAN JOIN UP, OR EACH LETTER CAN STAND ON ITS OWN. THEY ARE OFTEN DRAWN WITH AN INK PEN OR A BRUSH.

SCRIPTS ARE QUICK AND LIVELY, AND ARE USUALLY DRAWN WITH ONE LINE RATHER THAN BY FIRST DRAWING AN OUTLINE AND FILLING IT IN — THOUGH THAT CAN WORK TOO!

ABCDEFGHIJKL
MNOPQRSTUVW
, & ! ? XYZ $ £ € .
abcdefghijklm
nopqrstuvwxyz
1234567890
Light Medium **Bold**

PRACTICE TRACING THE *STYLES* OF LETTERING SHOWN HERE: DATE: _____

Script

ABCDEFGHIJKL
MNOPQRSTUVW
, & ! ? XYZ $ $ £ € .
abcdefghijklm
nopqrstuvwxyz
1234567890
Light Medium **Bold**

7 STYLE VARIATIONS

AS WELL AS THE BASIC STYLES, EACH CAN COME IN A HUGE RANGE OF VARIATIONS.

'EXTENDED' IS WIDER, 'CONDENSED' IS TALLER AND NARROWER. 'ITALIC' LEANS TO THE RIGHT.

Sans Italic Sans Condensed

Sans Extended

Sans Condensed Italic

Serif Italic Serif Condensed

Serif Extended

Serif Condensed Italic

Script Italic Script Condensed

Script Extended

Script Condensed Italic

DATE:

Sans Italic Sans Condensed

Sans Extended

Sans Condensed Italic

Serif Italic Serif Condensed

Serif Extended

Serif Condensed Italic

Script Italic Script Condensed

Script Extended

Script Condensed Italic

8 FANCY LETTERING STYLES

IS IT A SANS? IS IT A SERIF? IS IT A SCRIPT? WHO KNOWS! SOME LETTERING DOESN'T FIT NEATLY INTO ANY STYLE — IT JUST FOLLOWS ITS OWN RULES.

THESE STYLES ARE OFTEN THE MOST FUN TO DRAW. TRY SOME OF THESE, THEN CREATE SOME OF YOUR OWN FOR THE PROJECTS IN THIS BOOK!

ART NOUVEAU ROUGH AND SCARY Old Fashioned CURVED Tattoo

WOBBLY AND WEIRD CRAGGY All on one line crumbly

HEAVY MESSY STENCIL Balloon PLAYFUL

Happy? Gothic Outlined CIRCLES AND LINES STAMPED

FUTURISTIC OUTLINED Computer CURLY LINES

BRUSHY Circular DOTTY Inline Funky Wild West

Classical LONG SPINDLY METALLIC PAINTED

COMPUTER SHADOW SHINY dots Ancient Manuscript

BOXED MONSTERS Script GRUNGY BLOCKY

Square POSTAGE STAMP Playful BOXED

NEON LIGHTS WILD WEST HEAVY METAL PAPER CUTOUT

PARALLEL LINES ACTION PACKED Refined Fairytale

Victorian Outline Feminine COSMIC lines Flowers

WHIMSICAL WESTERN Backslanted OUTINE SHADOW

Script Serif Shadow Computer SCI-FI WOODEN

RUBBER STAMP SPEEDY SPLIT SERIF BIG BRUSH

FAT BRUSH CARDBOARD BOX LIGHTNING HOLES AND BONES

BLOCKS STRIPY Space-Age FLASH SCANNER

SERIF SHADOW WORN-OUT TYPEWRITER TALL BRUSH

COPY THE EXPAMPLES OPPOSITE OR CREATE YOUR OWN
BRAND-NEW LETTERING STYLES HERE:

DATE:

9 LETTER STENCILS

A FAST WAY TO MAKE LETTERING IS TO USE STENCILS— MASKS CUT OUT OF PAPER OR CARD. BY CAREFULLY DABBING PAINT THROUGH THE HOLES OR DRAWING INSIDE THE SHAPES WITH A FELT PEN, PENCIL OR BIRO, YOU CAN MAKE YOUR OWN STENCIL LETTERING.

BY MOVING THE STENCIL, YOU CAN SPELL OUT ANY MESSAGE YOU LIKE. TRY DIFFERENT COLOURS OR OVERLAPPING THE LETTERS. CUT CAREFULLY — STENCIL LETTERING NEEDS 'CONNECTORS' TO HOLD ONTO THE INSIDES OF LETTERS LIKE THE "O" OR "A".

ABCDEFGHI
JKLMNOPQR
STUVWXYZ

COPY THESE LETTERS ONTO PAPER OR CARD, THEN CUT THEM OUT. TO MAKE THE JOB EASY, COPY THE LETTERS AS LARGE AS YOU CAN! YOU MAY NEED SEVERAL SHEETS. CARE SHOULD BE TAKEN WHEN USING SCISSORS OR KNIVES. NEXT YOU CAN TRY AND DESIGN YOUR OWN STENCIL LETTERING ALPHABETS.

1234567890

.,O-?!&./+=

USE STENCIL LETTERS TO SPELL OUT YOUR NAME HERE.
TRY DIFFERENT STYLES AND COMBINATIONS:

DATE:

10 COMPUTER LETTERING

EARLY COMPUTER LETTERING WAS BASED ON A SIMPLE GRID OF BOXES, OR PIXELS.

EVEN WITH A RIGID GRID, IT IS POSSIBLE TO CREATE A WIDE VARIETY OF STYLES.

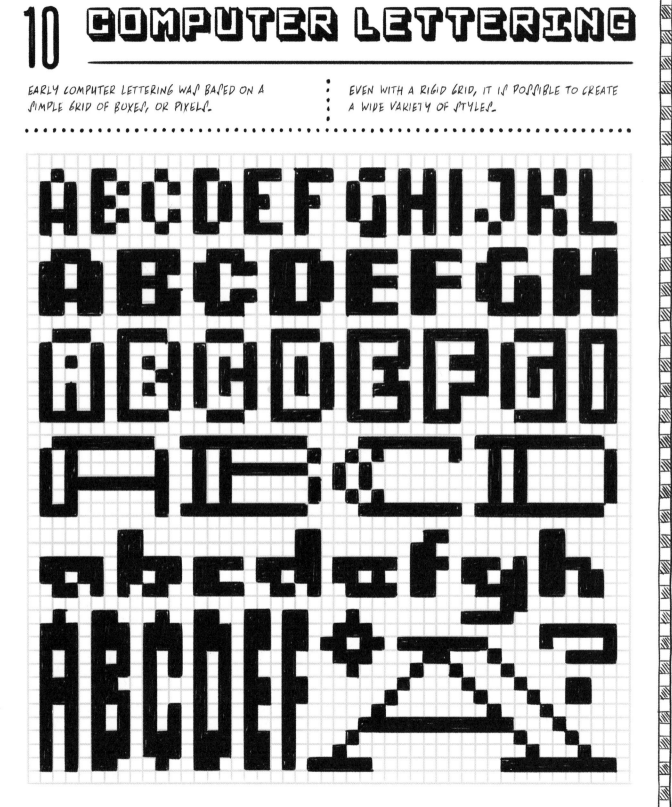

FILL IN BOXES TO CREATE YOUR OWN PIXEL GRID LETTERING: DATE:

11 ACTION LETTERING

DON'T THINK THAT YOUR LETTERING NEEDS TO BE ORDINARY. LETTERING CAN GET IN ON THE ACTION!

HERE ARE SOME IDEAS FOR HOW YOU CAN BRING YOUR LETTERING TO LIFE. YOU CAN APPLY THEM OPPOSITE.

SHATTER SPEED

WEEEEEEEE!ROUND IN A CIRCLE...

SMALL

OVERLAPPING MIXED UP

DIFFERENT STYLES BULLETHOLES

EXPLODE SINKING DIFFERENT SIZES

DRIPPING DIRTY

KNOCKOUT SHAKE CUTUP

TORN LETTERS CRAGGY

BIG

DRAW THE WORDS HERE, ADDING SOME DYNAMIC ACTION: DATE: []

BOMB SQUAD

SUBMARINE

BROKEN MIRROR

SUPERSONIC

AROUND THE WORLD

HUGE AND TINY

12 SIMPLE EMBROIDERY LETTERING

USING SPECIAL FABRIC WITH ROWS OF HOLES IN CALLED "BINCA" IT IS POSSIBLE TO MAKE MANY STYLES OF LETTERING USING A NEEDLE AND THREAD.

FINISHED PIECES THAT SHOW OFF THE SKILLS OF THE EMBROIDERER ARE CALLED "SAMPLERS". HERE ARE SOME SIMPLE ALPHABET EXAMPLES:

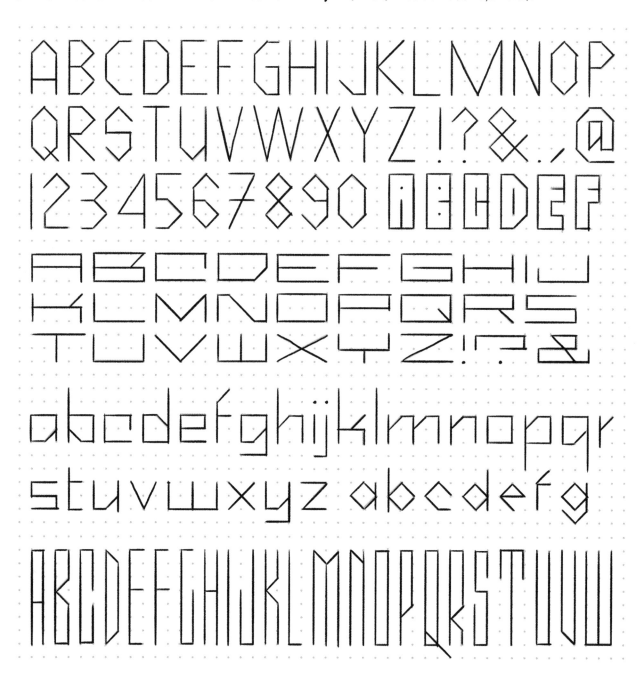

CREATE YOUR OWN ALPHABET SAMPLER HERE:

DATE:

13 LETTER PORTRAITS

TAKE THE LETTERS OF YOUR NAME AND ARRANGE THEM TO CREATE A LETTER PORTRAIT. DOES IT LOOK LIKE YOU?

NEXT, TRY CREATING PORTRAITS OF YOUR FRIENDS. TRY FAMOUS PEOPLE AND FICTIONAL CHARACTERS TOO!

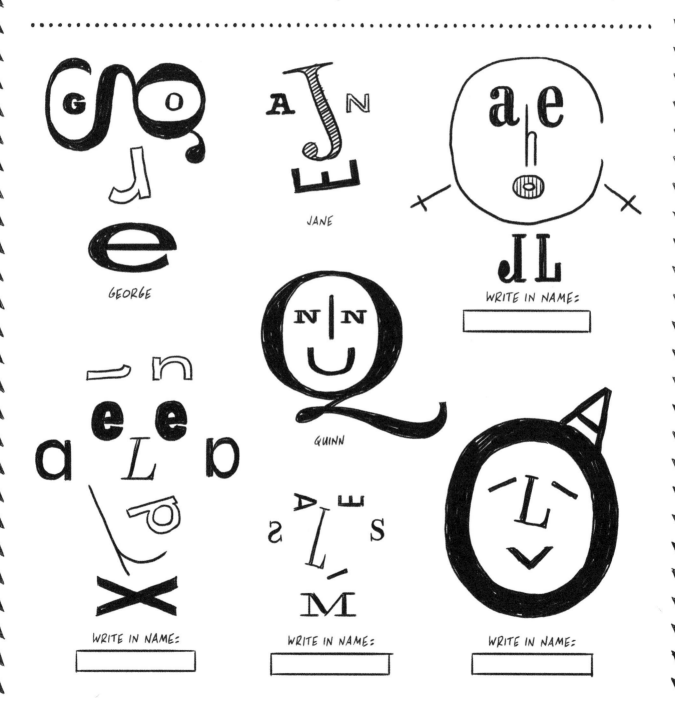

GEORGE

JANE

QUINN

WRITE IN NAME:

WRITE IN NAME:

WRITE IN NAME:

WRITE IN NAME:

YOUR LETTER PORTRAIT GALLERY:

DATE:

A LETTER PORTRAIT OF ME!

A LETTER PORTRAIT OF:

A LETTER PORTRAIT OF:

A LETTER PORTRAIT OF:

A LETTER PORTRAIT OF:

A LETTER PORTRAIT OF:

14 3D LETTERING

WHO SAYS LETTERING HAS TO SIT ALONG A STRAIGHT LINE? WHY NOT MAKE IT BOUNCE OR JUMP, OR SQUASH OR SQUEEZE IT?

THERE ARE INFINITE WAYS TO TWIST AND TURN YOUR LETTERING IN THREE DIMENSIONS! TRY SOME OF THE SUGGESTIONS OPPOSITE.

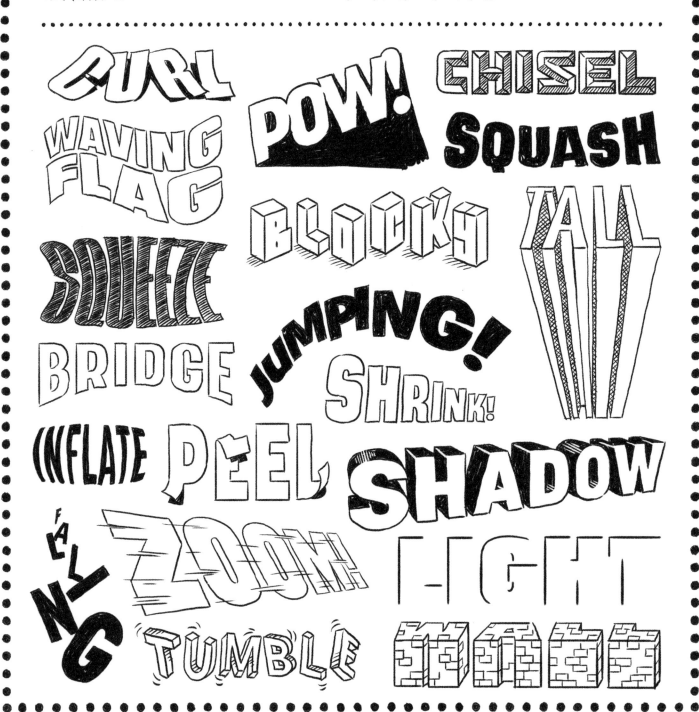

DRAW YOUR 3D LETTERING HERE USING THE GUIDES TO HELP:

DATE:

ARCHED

BOUNCING

SAGGING

WHIZZING

TWISTING

ROUND IN A CIRCLE

15 YOUR NAME IN LIGHTS

BY USING A SQUARE MADE OF TWENTY-FIVE CIRCLES, YOU CAN MAKE EVERY LETTER OF THE ALPHABET.

A SIMILAR IDEA IS USED FOR THE "NEXT TRAIN" AND "NEXT BUS" SIGNS AT STATIONS AND BUS STOPS.

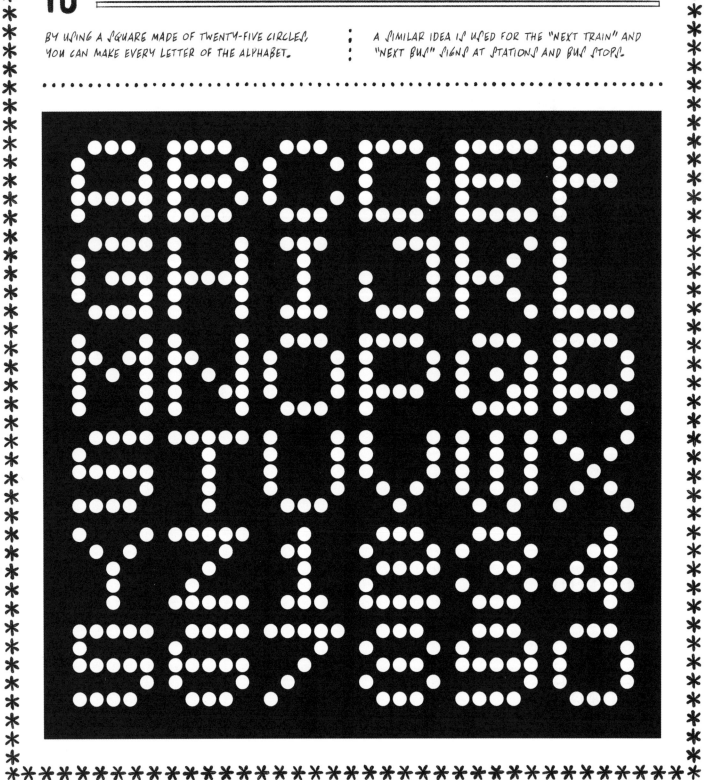

DRAW YOUR OWN MESSAGE IN LIGHTS BY BLACKING IN DOTS: DATE: []

16 LETTERS ON FIRE!

LETTERS THAT ARE ON FIRE? OR HAVE ICICLES HANGING FROM THEM? OR ARE MADE OF PUFFS OF SMOKE?

THERE ARE MANY WAYS TO MAKE YOUR LETTERING LOOK LIKE WHAT IT DESCRIBES.

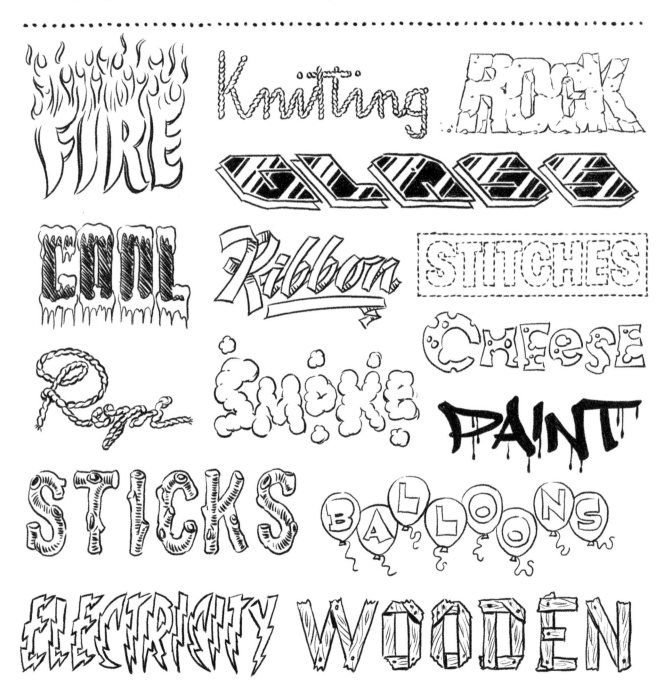

MAKE THESE WORDS LOOK LIKE WHAT THEY SAY:

DATE:

WATER

FOOTBALLS

WIND

BRICKS

GRASS

SNOW

17 LETTER RUBBING

PLACE THE PAGE OVER AN EMBOSSED LETTER, AND RUB OVER WITH A PENCIL OR CRAYON. MOVE THE PAPER BETWEEN RUBBINGS TO CREATE YOUR OWN WORDS!

TRY
COINS
STREET NAMES
OLD EMBOSSED TINS
MANHOLE COVERS
GRAVESTONES

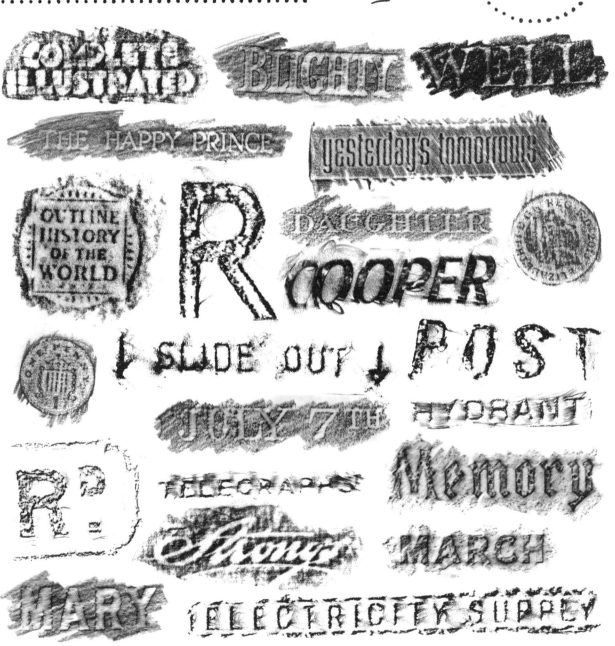

COLLECT YOUR LETTER RUBBINGS HERE:

DATE:

18 WORD SHAPES

WORDS CAN BE DRAWN TO LOOK LIKE OBJECTS. HERE ARE SOME EXAMPLES — NOW TRY YOUR OWN!

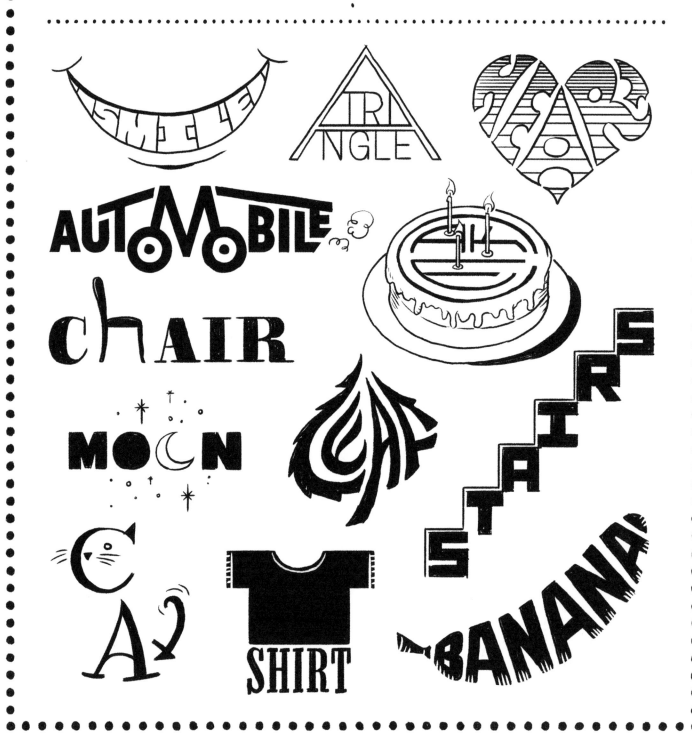

TRY MAKING THESE WORDS LOOK LIKE THE THINGS THEY DESCRIBE: DATE:

A GIRAFFE

A TRAIN

A TREE

AN APPLE

A HOUSE

A SPOON

19 STYLES OF SERIF

"SERIFS" ARE THE "FEET" AT THE END OF A LETTER'S STROKES. THEY COME IN MANY SHAPES AND SIZES.

FINISH THE LETTERS OPPOSITE BY ADDING SOME OF YOUR OWN INVENTION!

20 MOSAIC LETTERING

OLD SHOPS OFTEN HAD BEAUTIFUL LETTERING MOSAICS IN THE DOORWAY TO WELCOME YOU IN. BELOW YOU CAN SEE PHOTOGRAPHS OF SOME THAT STILL SURVIVE.

KEEP AN EYE OUT AND SEE IF YOU CAN PHOTOGRAPH SOME YOURSELF. WHY NOT KEEP A PHOTO SCRAPBOOK OF INTERESTING LETTERING YOU COME ACROSS?

YOU CAN MAKE PAPER TILES BY CUTTING OUT LITTLE BLACK AND WHITE SQUARES FROM MAGAZINES OR NEWSPAPERS, OR BY COLOURING THEM IN YOURSELF. STICK THEM DOWN USING THE DESIGN OPPOSITE AS A GUIDE.

NEXT, TRY YOUR OWN MOSAIC LETTERING DESIGNS. HERE'S A TIP: SKETCH THEM OUT IN PENCIL FIRST!

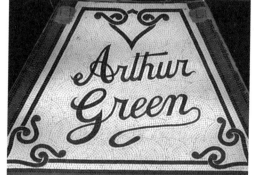
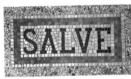
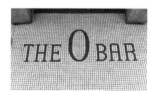
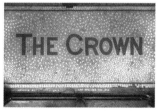
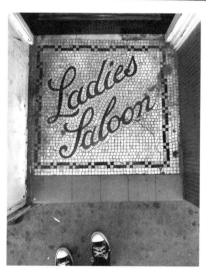

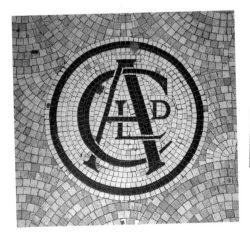

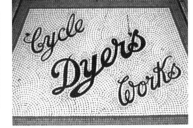

CREATE YOUR LETTERING MOSAIC HERE:

WE STARTED YOU OFF

21 FUN FAIR LETTERING

ROLL UP! ROLL UP! THE FUN FAIR IS A GREAT PLACE TO FIND AMAZING HAND-PAINTED LETTERING IN HUNDREDS OF STYLES AND BRIGHT COLOURS.

BELOW ARE SOME REAL FUN FAIR SIGNS. THEY HAVE EVERYTHING — SHADOWS, OUTLINES, BANNERS, NEON LIGHTS AND MORE.

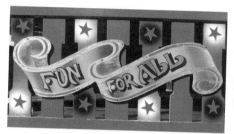

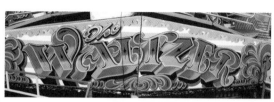

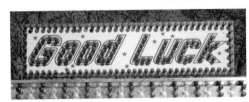

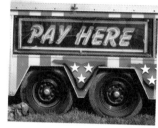

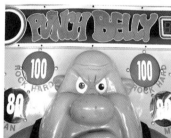

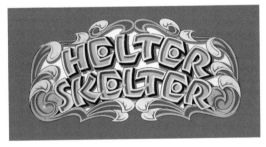

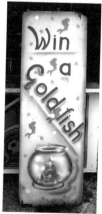

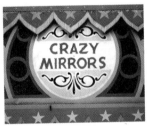

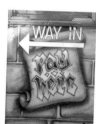

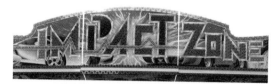

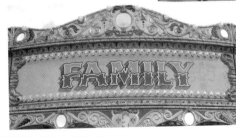

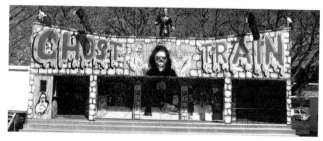

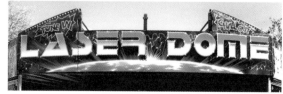

NOW CREATE YOUR OWN FANCY LETTERING FOR THESE
FUN FAIR RIDES:

DATE:

DUCK SHOOT

CAROUSEL

BUMPER CARS

FERRIS WHEEL

HAUNTED HOUSE

TUNNEL OF LOVE

22 INITIAL LETTERS

INITIALS ARE A BIT LIKE DECORATIVE MONOGRAMS, BUT ONLY HAVE ONE LETTER. THEY USED TO BE USED IN BOOKS AT THE BEGINNING OF EACH NEW CHAPTER.

TAKE A LOOK AT THE INITIAL LETTERS BELOW. THEY CAN BE DRAWN IN ANY AND EVERY STYLE YOU CAN IMAGINE. NOW HAVE A GO AT CREATING YOUR OWN OPPOSITE.

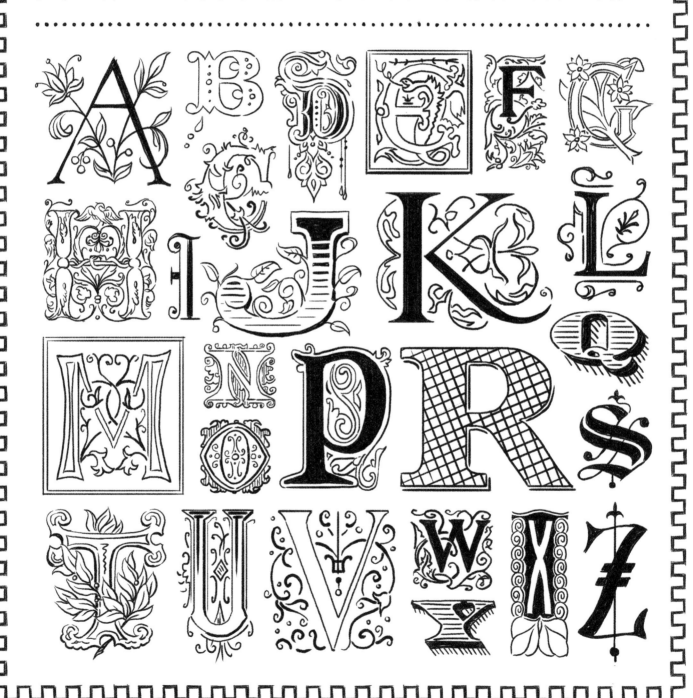

A B C D E

F G H I J K

L M N O P

Q R S T U

V W X Y Z

23 ANYTHING CAN BE LETTERING!

ALMOST ANYTHING CAN BE USED TO MAKE LETTERS, NOT JUST PENS, PENCILS AND BRUSHES! TAKE A LOOK AROUND, AND SEE WHAT YOU CAN USE TO MAKE INTERESTING LETTER SHAPES.

HERE ARE SOME EVERYDAY OBJECTS THAT HAVE BEEN PHOTOGRAPHED AND ARRANGED AS AN ALPHABET. PHOTOGRAPH YOUR OWN, THEN PRINT THEM OUT, OR IF YOU DON'T HAVE A CAMERA, YOU CAN DRAW THEM.

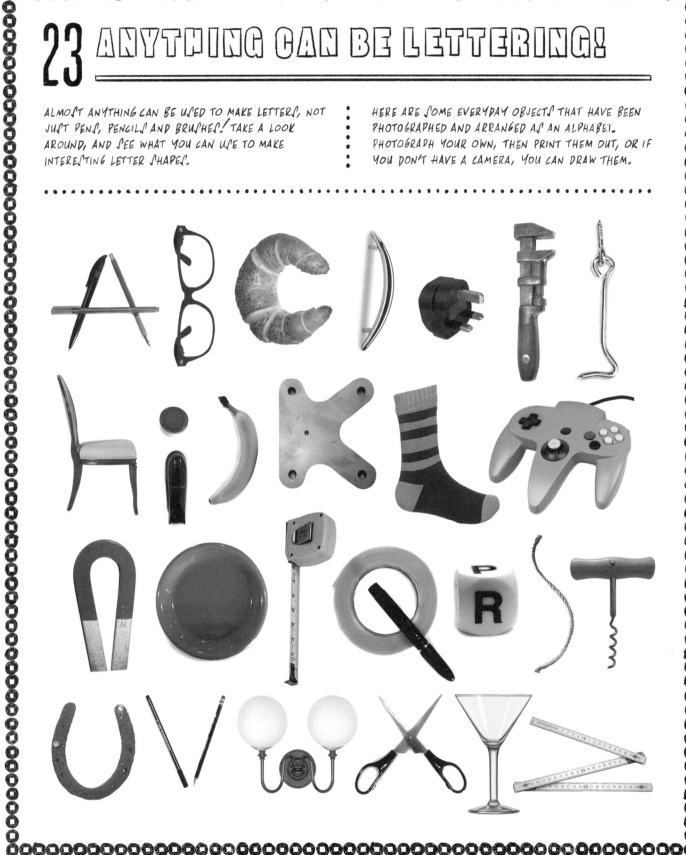

PASTE OR DRAW YOUR OWN OBJECT ALPHABET HERE: DATE:

24 MORE GRID-BASED LETTERING

BY MAKING THE GRID SMALLER, MORE DETAIL CAN BE ADDED TO YOUR LETTERING STYLES.

SERIF, SHADOW, REVERSED, OUTLINE AND OTHER DECORATIVE STYLES CAN BE CREATED.

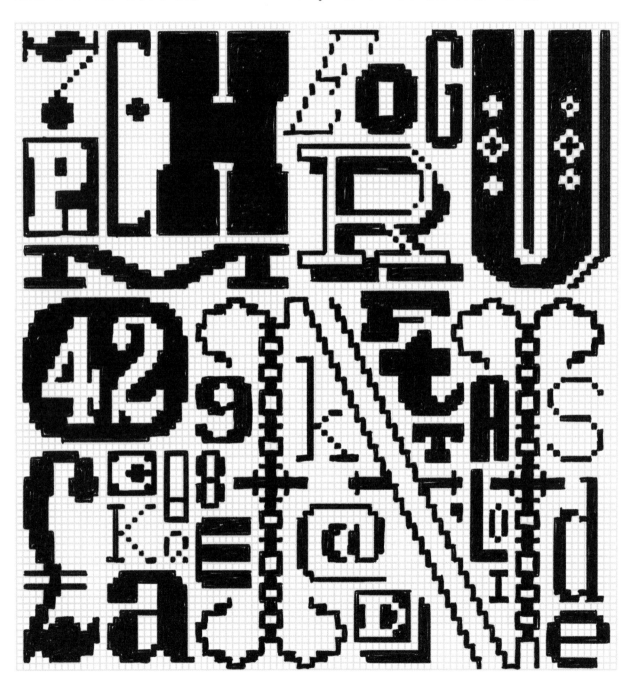

DESIGN YOUR OWN PIXEL LETTERS ON THE GRID BELOW
BY COLOURING IN SQUARES:

DATE:

25 CUT-OUT PAPER TYPE

BRIGHT AND STRIKING LETTERING CAN BE CUT FROM COLOURED PAPER OR OLD MAGAZINES. A SIMPLE SANS SERIF STYLE WORKS BEST, THOUGH ONCE YOU'VE MASTERED THAT, TRY MORE COMPLICATED STYLES.

TAKE A LOOK AT THE EXAMPLE ON THIS PAGE, THEN CUT OUT YOUR OWN ALPHABET AND PASTE IT DOWN ON THE OPPOSITE PAGE. TRY USING DIFFERENT COLOUR PAPERS AND OVERLAPPING YOUR LETTERS.

ABCDEFG
HIJKLMNO
PQRSTUVW
→XY&Z←
1234567890

PASTE OR TAPE YOUR CUT-OUT LETTERS HERE: DATE:

26 SPEECH BUBBLES

Is it a whisper or a shout? A thought or a scream? The shape of the bubble suggests the tone of the voice.

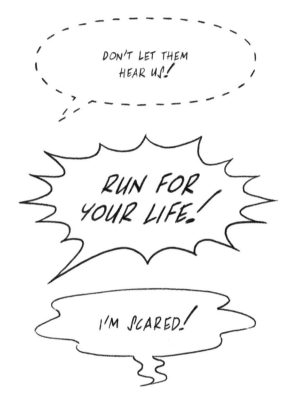

ADD SUITABLE BUBBLES AROUND THESE WORDS:-

HELP, ME!

I WONDER WHAT'S FOR DINNER...

AARGH!

WELCOME TO MY DAMP DUNGEON

WILL YOU MARRY ME, DARLING?

I FEEL A BIT QUEASY....

I AM ALL POWERFUL! I RULE THE WORLD!!!

...AND ADD SUITABLE WORDS TO THESE BUBBLES!

DATE:

27 SHOP FRONT LETTERING

AS YOU WALK DOWN THE HIGH STREET, LOOK UP AT THE SHOP SIGNS ABOVE YOU. YOU WILL SEE LETTERING IN MANY SIZES AND STYLES.

UNUSUAL AND EYECATCHING DESIGNS WILL GRAB THE ATTENTION OF PASSERS-BY, AND ENCOURAGE THEM TO COME INTO YOUR SHOP TO BROWSE.

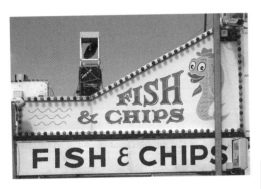
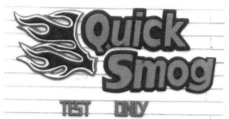
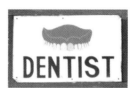
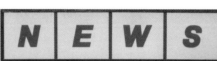
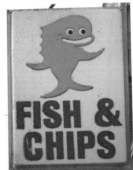
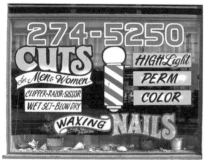

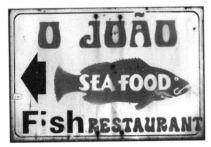
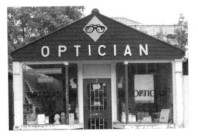
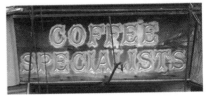
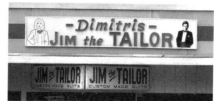
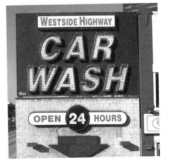
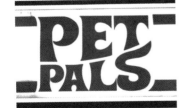
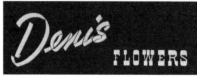
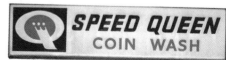

ADD THE LETTERING TO THESE SHOP FRONTS.
DONT FORGET TO ADD SIMPLE PICTURES, TOO!

DATE:

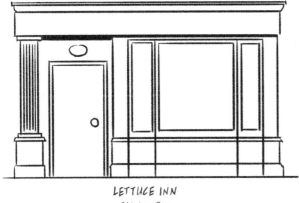

LETTUCE INN
SALAD BAR

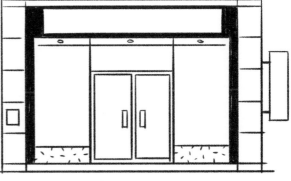

SEW AND TELL
HABERDASHERS

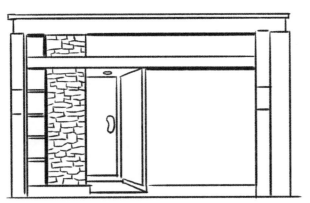

SHORT AND CURLIES
HAIRDRESSERS

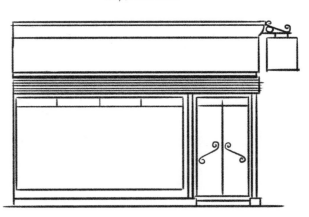

FRYING NEMO
FISH AND CHIP SHOP

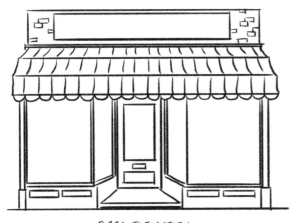

PIZZA THE ACTION
ITALIAN RESTAURANT

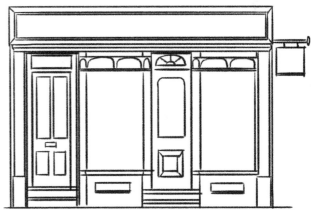

FOXED AND TATTY
BOOKSHOP

28 GRAFFITI TAGS

GRAFFITI IS WRITING OR DRAWING THAT IS SCRIBBLED, SCRATCHED, DRAWN OR PAINTED ON A WALL OR OTHER PUBLIC PLACE. GRAFFITI CAN BE A SIMPLE WRITTEN WORD OR AN ELABORATE PAINTING, AND THEY HAVE EXISTED SINCE PREHISTORY. THERE ARE EXAMPLES FROM ANCIENT EGYPT, ANCIENT GREECE, AND THE ROMAN EMPIRE.

IN MODERN TIMES, SPRAY PAINT AND MARKER PENS HAVE BECOME THE MOST COMMONLY USED TOOLS FOR GRAFFITI ARTISTS.

A GRAFFITI "TAG" IS THE ARTIST'S NICKNAME, WRITTEN IN A QUICK AND UNIQUE WAY, JUST LIKE A SIGNATURE.

BUT BEWARE — PAINTING GRAFITTI WITHOUT PERMISSION ON SOMEONE ELSE'S PROPERTY IS CALLED VANDALISM, WHICH IS AGAINST THE LAW!

PRACTICE YOUR GRAFF TAGS HERE INSTEAD, WHERE THE POLICE CAN'T FIND YOU.

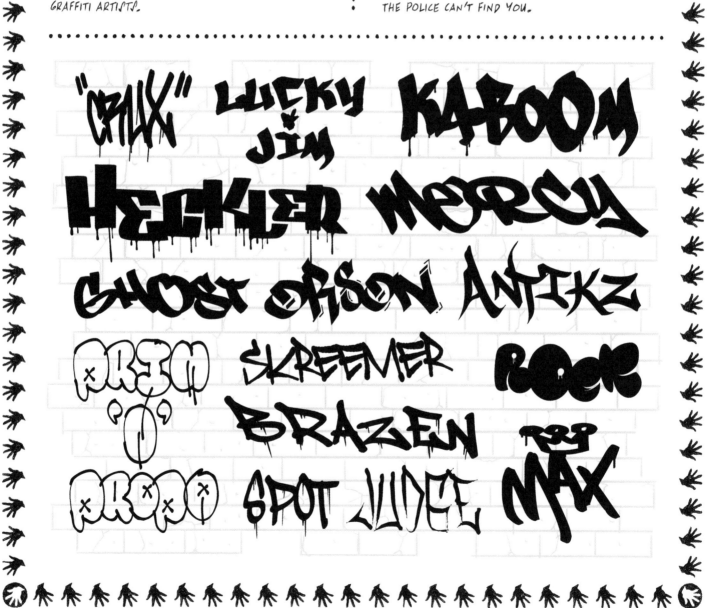

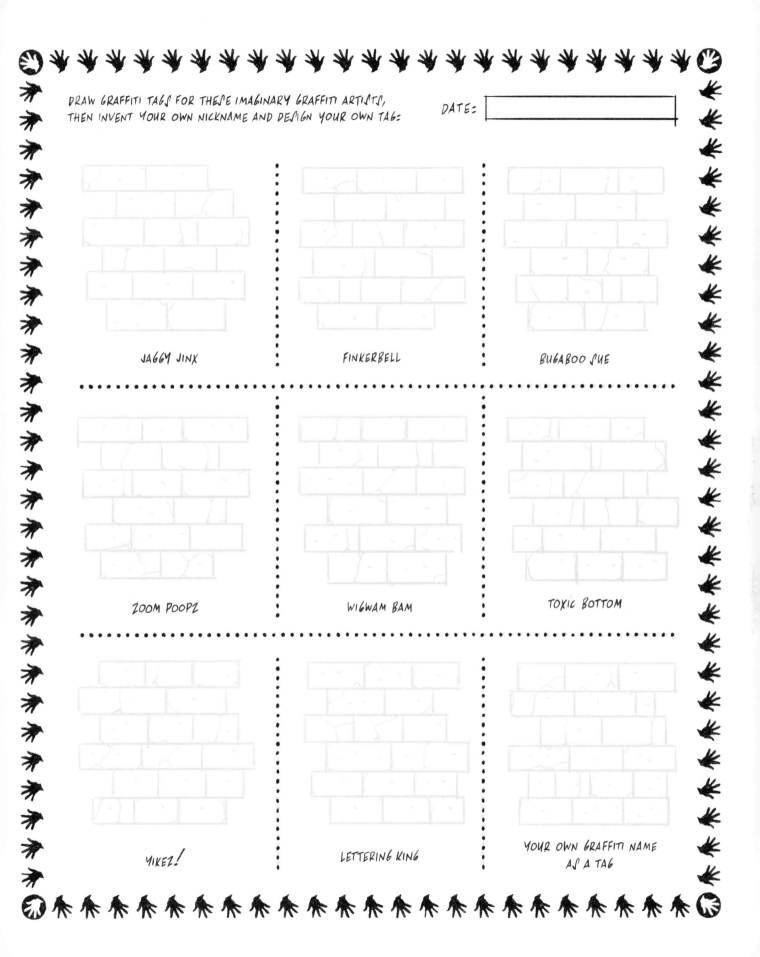

DRAW GRAFFITI TAGS FOR THESE IMAGINARY GRAFFITI ARTISTS, THEN INVENT YOUR OWN NICKNAME AND DESIGN YOUR OWN TAG:

DATE:

JAGGY JINX

FINKERBELL

BUGABOO SUE

ZOOM POOPZ

WIGWAM BAM

TOXIC BOTTOM

YIKEZ!

LETTERING KING

YOUR OWN GRAFFITI NAME AS A TAG

29 RANSOM NOTES

YOU'VE KIDNAPPED SANTA'S ELVES AND ARE HOLDING THEM TO RANSOM! CUT OUT LETTERS FROM NEWSPAPERS AND MAGAZINES AND PASTE THEM DOWN HERE TO CREATE YOUR RANSOM NOTE.

WE'VE STARTED YOU OFF ALREADY BELOW. WHAT WILL YOU ACCEPT FROM SANTA IN EXCHANGE FOR THE ELVES' SAFE RETURN?

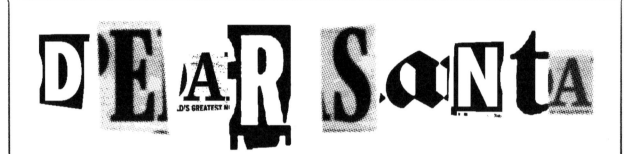

CONTINUE YOUR RANSOM NOTE HERE:
WHAT WILL HAPPEN TO THE ELVES IF YOUR DEMANDS ARE NOT MET?

DATE:

30 BOOK COVERS

YOU HAVE JUST WRITTEN WHAT IS SURE TO BE A BEST-SELLING NOVEL! IT'S SO THRILLING IT'LL UNDOUBTEDLY BE MADE INTO A MAJOR FILM, TOO. NOW ALL YOU NEED IS A GREAT COVER.

DON'T FORGET TO INCLUDE THE AUTHOR'S NAME — THAT'S YOU — AND THE TITLE OF YOUR EPIC TALE. THE STYLE OF THE LETTERING SHOULD SUIT THE STYLE OF YOUR STORY.

JELLYHEAD INVASION *FROM MARS*
BY A. FAMOUS WRITER

HOW TO BULLY YOUR WAY TO FAME AND Riches
BY A. FAMOUS WRITER

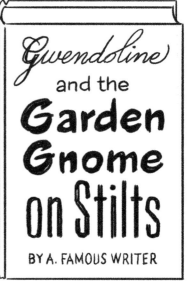

Gwendoline and the Garden Gnome on Stilts
BY A. FAMOUS WRITER

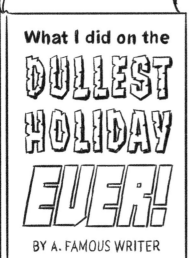

What I did on the DULLEST HOLIDAY EVER!
BY A. FAMOUS WRITER

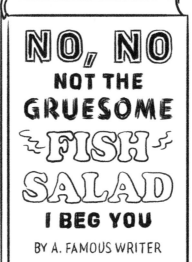

NO, NO NOT THE GRUESOME FISH SALAD I BEG YOU
BY A. FAMOUS WRITER

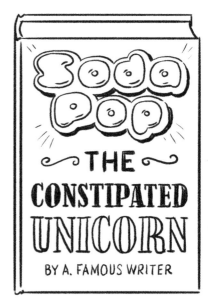

Soda Pop THE CONSTIPATED UNICORN
BY A. FAMOUS WRITER

THERE ARE ENOUGH BLANK COVERS HERE FOR YOU TO
DESIGN THE SEQUELS, TOO:

DATE:

31 YOU'VE STARTED A BAND...

AND YOU'RE DESTINED FOR STARDOM!

DON'T WORRY IF YOU CAN'T PLAY AN INSTRUMENT OR SING — MERE DETAILS!

THE MOST IMPORTANT THING EVERY SUCCESSFUL BAND HAS IS A MEMORABLE LOGO. YOUR MILLIONS OF ADORING FANS WILL NEED SOMETHING TO SCRAWL ON THEIR DESKS AND WEAR ON THEIR T-SHIRTS.

WHAT SHOULD IT LOOK LIKE?

WELL, WHAT KIND OF MUSIC YOU WANT TO PLAY? ROCK? METAL? COUNTRY? POP? CLASSICAL? SYNTHESIZER? BAGPIPES?

THE NAME OF YOUR BAND AND THE DESIGN OF YOUR LOGO SHOULD REFLECT THE STYLE OF THE MUSIC YOU'RE GOING TO PLAY.

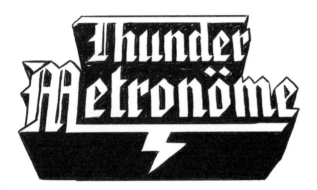

THUNDER METRONOME

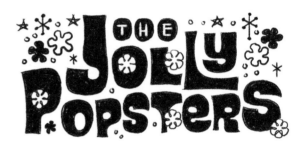

THE JOLLY POPSTERS

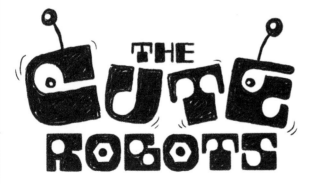

THE CUTE ROBOTS

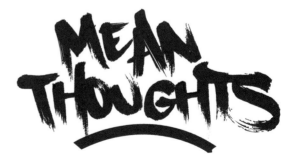

MEAN THOUGHTS

DESIGN LOGOS FOR THESE UPCOMING NEW BANDS, AND THEN ADD YOUR OWN BAND'S LOGO DESIGN:

DATE:

THE MOONLIGHT PIANO SERENADERS

SPANGLY SPARKLE AND THE SPRINKLES

RALF AND THE SOGGY BOTTOMS

ARMAGEDDON TROUSERS

THE FUNKY JUMPERS

YOUR BAND NAME:

32 LETTER AN INVITATION

THERE'S A SUMMER CARNIVAL TAKING PLACE IN YOUR STREET! USING YOUR STENCILS MIXED WITH HAND-DRAWN LETTERING, MAKE SOME INVITATIONS THAT CAN BE POSTED THROUGH EVERYONE'S LETTERBOX.

THE INVITATIONS NEED TO LET EVERYONE KNOW ABOUT ALL THE FUN THINGS THAT WILL BE HAPPENING. HERE'S A LIST OF EVERYTHING YOU NEED TO INCLUDE. NOW YOU'VE BEEN "BRIEFED", GET TO IT!

BRIEF FOR SUMMER
CARNIVAL POSTER
- - - - - - - - - - - - - - - - -

At the top please put:

COME TO THE STREET'S
SUMMER CARNIVAL

then under that:

THIS SATURDAY 12-6PM

...then add as many of these rides and attractions as you can fit in, dotted around:

BOUNCY CASTLE

WATER SLIDE

HELTER SKELTER

CAKE STALL

COCONUT SHY

TOMBOLA

PIRATE SHIP

CAROUSEL

RAFFLE

PONY RIDES

FACE PAINTING

HOT DOGS

PUNCH AND JUDY SHOW

LIVE MUSIC FROM
"DJ YOUR DAD"

EARPLUGS
(FOR ADULTS ONLY)

FULLY LICENCED BAR
(FOR ADULTS ONLY)

...then at the bottom:

PRIZE FOR BEST
CARNIVAL OUTFIT!

SEE YOU THERE!

CREATE YOUR INVITATION HERE: DATE:

33 SOUND EFFECTS

BANG! CRASH! POW!

SOUND EFFECTS SHOULD LOOK LIKE THE NOISE THEY REPRESENT, SO THAT WHEN YOU SEE THE LETTERING YOU CAN HEAR THE SOUND IN YOUR IMAGINATION.

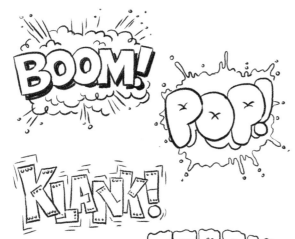

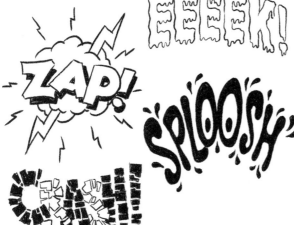

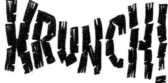

WHAT DO YOU THINK THESE SOUNDS SHOULD LOOK LIKE? DRAW THEM IN THE SPACES BELOW:

A CAR HORN:
"HONK!"
←

A DOORBELL:
"BUZZ!"
→

GLASS BREAKING:
"SMASH!"
←

A WHISTLE BLOWING:
"WHEEEE!"
→

THUNDER AND LIGHTNING:
"KA-KRAKK!"
←

TRUMPETS PLAYING:
"TOOT TOOT!"
→

WHAT KIND OF SOUND MIGHT A PIANO DROPPED FROM AN
AIRPLANE MAKE? OR SOMEONE SITTING ON A RIPE MELON?
COME UP WITH YOUR OWN SOUNDS, THEN DRAW THEM HERE:

DATE:

SCRUNCHING UP
BUBBLE-WRAP

A DOG BARKING

OPENING A BOTTLE
OF FIZZY DRINK

CUTTING DOWN A TREE
WITH A CHAINSAW

FOOTSTEPS IN SNOW

STEPPING ON A
CHOCOLATE CAKE

BUNGEE JUMPING

BLOWING BUBBLES UNDERWATER

COMPLETE SILENCE

34 MONSTER LETTERING

Scary movies need equally scary posters to advertise them! You've just filmed the spookiest film ever. What is it to be called?

Decide on a terrifying name for your movie, then using the lettering examples below for inspiration, design a horrifying poster!

MADNESS

BAT

SINISTER

UNKNOWN

CEMETERY

SPECTRE PHANTOM

BLOODY

FEAR TERROR

HORROR

DRACULA BOMB

HAUNTED

IT!

MONSTER

NERVES

SCREAM!

BEWARE

CREEPY

HORRIFIC!

DRAW YOUR SPINE-TINGLING POSTER HERE: DATE:

35 DESIGN A POSTER

ALFIE THE DOG LOOKS A BIT SAD.

THAT'S BECAUSE HE'S GONE AND GOT HIMSELF LOST! HE RAN OFF TO CHASE A SQUIRREL IN THE PARK, AND NOW HIS OWNERS CAN'T FIND HIM.

BUT YOU CAN HELP. IT'LL TAKE NO TIME AT ALL TO CREATE AN EYE-CATCHING POSTER! BELOW IS A LIST OF THE THINGS YOU NEED TO INCLUDE. THIS IS CALLED YOUR "BRIEF". ALFIE WILL BE BACK HOME IN NO TIME! *

Dear lettering artist (that's you!)

Please could you include the following items on the poster you have so kindly offered to make:

LOST! (That needs to be big, maybe at the top?)

ALFIE THE DOG

Then below that:
LAST SEEN IN THE PARK

RECOGNISEABLE BY DROOPY EARS
AND GLOOMY EXPRESSION.

We need to include our details too, so please add at the bottom:
IF FOUND PLEASE CALL HIS OWNERS:
0123 456 7890

If we have space, can you add:
REWARD: HOME-BAKED CARROT CAKE

THANK YOU - ALFIE'S OWNERS

*HE ACTUALLY RAN AWAY BECAUSE ALL HE WAS GIVEN TO EAT WAS CARROT CAKE. ALFIE HATES CARROT CAKE. HE HAS BEEN ADOPTED BY GEORGE THE BUTCHER, WHO FEEDS HIM ON GROUSE AND BACON BITS. HE IS MUCH HAPPIER WITH HIS NEW OWNER, BUT DON'T TELL ANYONE.

CREATE YOUR POSTER HERE AROUND ALFIE'S PHOTO: DATE:

36 WILD WEST WANTED POSTER

CRIME DOES NOT PAY!

AS SHERRIF OF DEAD DONKEY GULCH, YOU ARE RESPONSIBLE FOR LAW AND ORDER IN THIS TOWN.

A NOTORIOUS BANDIT NAMED SIXSHOOTER SUE IS ON THE RUN, AND SHE'S HEADING THIS WAY.

THERE'S A BIG REWARD FOR HER CAPTURE. YOU NEED TO PUT UP SOME POSTERS, PRONTO!

WHAT IS HER HORRIBLE CRIME?

HOW MUCH IS THE REWARD?

HERE IS SOME OLD-FASHIONED WILD WEST STYLE LETTERING FOR YOU TO USE.

YOU WILL ALSO NEED TO SKETCH A PORTRAIT, SO HONEST TOWNSFOLK CAN RECOGNISE HER UGLY, MEAN FACE. WHAT DO YOU THINK SHE LOOK LIKE?

REWARD! WANTED

!REWARD!

To be Paid for the Arrest of **GHASTLY**

Dead · or · Alive

$5000 ⁰⁰ BOUNTY

$800

CONSIDERED TO BE ARMED
& EXTREMELY DANGEROUS!

DEAD ᴏʀ ALIVE REWARD $2000 ⁰⁰

WANTED

REWARD FOR THE CAPTURE, DEAD OR ALIVE OF

ARRANGE SOME OF THE LETTERING OPPOSITE AND ADD MORE OF
YOUR OWN INVENTION TO MAKE YOUR "WANTED POSTER" HERE:

DATE:

ATTENTION ALL TOWNSFOLK!

A TRUE LIKENESS OF THE ACCUSED

BY ORDER, THE SHERRIF OF DEAD DONKEY GULCH

37 LETTERS AROUND THE WORLD

THE LETTERS THAT YOU MAY BE FAMILIAR WITH FROM THE ALPHABET AREN'T THE ONLY LETTERS AROUND!

HERE ARE SOME UNUSUAL LETTERS FROM FOREIGN ALPHABETS. WHAT SOUNDS MIGHT THEY MAKE?

Ų Ř Æ Å Đ ð Ç ê Ĕ Ħ ę Ł ł Ñ Ö Ø Œ

Γ Δ Θ Λ Ξ Π Σ Ï Υ Φ Ψ Ω

α β γ δ ε ζ η θ λ ξ π ς σ φ ω ψ ϕ ϖ ω χ

Ђ Љ Њ Ћ Џ Ж З Ю Я Ъ Ш Б б Э Щ

א ב ג ד ה ח ט ו מ ס פ ץ ע ך ל ם ע צ ש ו

ی ؤ أ ل ث ة ش ظ غ ق ك ک گ ص

ฅ ซ ย ม ภ ธ ด ณ ฐ ฎ ญ ช ฆ ฉ ฃ ฒ ฬ ๓

�‌ ၊ ယ သ ၎ ၈ ၅ ၁ ၃ ၵ ၥ ၀ ၒ

支 尖 天 井 只 尺 巴 旱 日 月 旺 盂 田 支 旨 坐

암 웟 졸 순 쁠 요 쫑 캥 팀 폿 농 램 론 빱 삽 해

CREATE YOUR OWN IMAGINARY LETTERS HERE: DATE:

38 POTATO PRINTING

OLD PRINTING TYPE WAS MADE FROM WOOD (FOR THE LARGE SIZES) AND METAL (FOR THE SMALL SIZES). THE INDIVIDUAL LETTERS WERE ARRANGED INTO WORDS, THEN INKED UP AND PRESSED ONTO PAPER USING A PRINTING PRESS.

IN A SIMILAR WAY, YOU CAN USE POTATO PRINTS TO CREATE YOUR OWN POTATO ALPHABET.

USE IT TO PRINT POSTERS, OR SIGNS FOR YOUR DOOR.

DON'T FORGET TO CARVE THE LETTERS BACK-TO-FRONT SO THAT WHEN THEY ARE PRINTED THEY ARE THE RIGHT WAY AROUND!

IF YOU ARE A CHILD, ASK AN ADULT FOR HELP.
IF YOU ARE AN ADULT, ASK A CHILD FOR HELP.

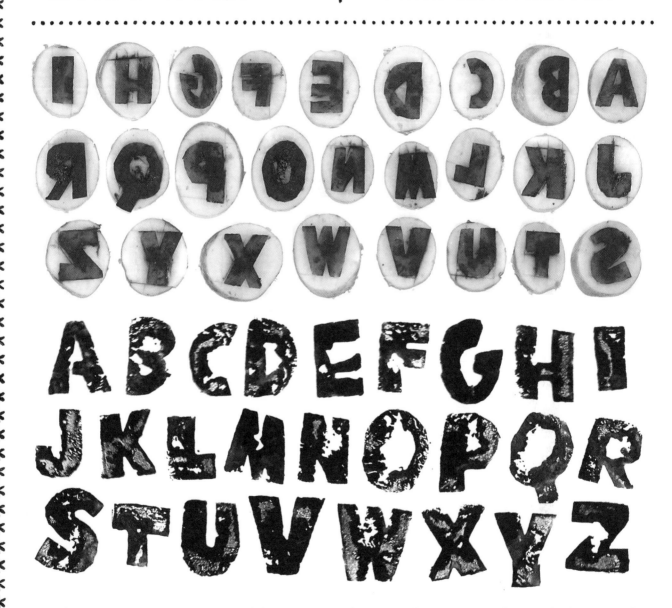

TRY OUT YOUR POTATO LETTERS HERE.
TRY USING DIFFERENT COLOURS:

DATE:

39 LETTERING WITH LIGHT

WITH A CAMERA OR CAMERAPHONE SET TO A LONG EXPOSURE, IT'S POSSIBLE TO WRITE WITH LIGHT.

YOU WILL NEED TO PICK A DARK NIGHT OR ROOM, AND FIND A TORCH OR A SPARKLER.

SPARKLERS SHOULD ONLY BE USED OUTSIDE.

IF YOU ARE A CHILD, YOU WILL NEED TO FIND AN ADULT TO HELP YOU. IF YOU ARE AN ADULT, YOU WILL NEED TO FIND A CHILD TO HELP YOU.

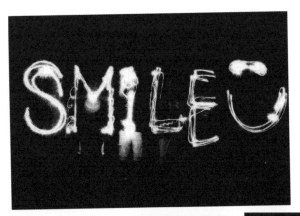
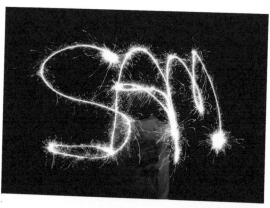
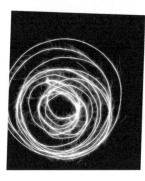
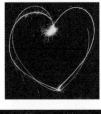
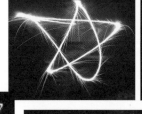
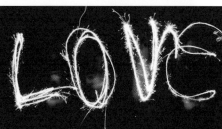
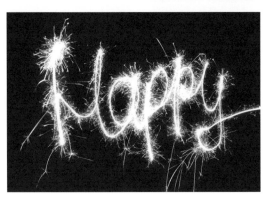
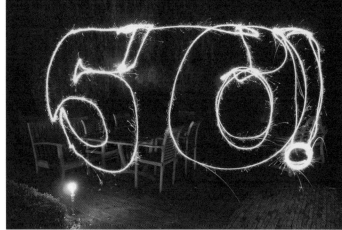

PHOTOS: NICK LAZAROW, SAM FOLES, DEBORAH AUSTIN, HEATHER

PRINT OUT YOUR PHOTOS AND PASTE THEM TO THIS PAGE. DATE:

IT'S POSSIBLE TO CREATE LETTERING USING ONLY CROSS-STITCH.

HERE IS A SERIF ALPHABET, WITH SOME ORNAMENTS. YOU COULD CREATE A DECORATIVE BORDER, TOO.

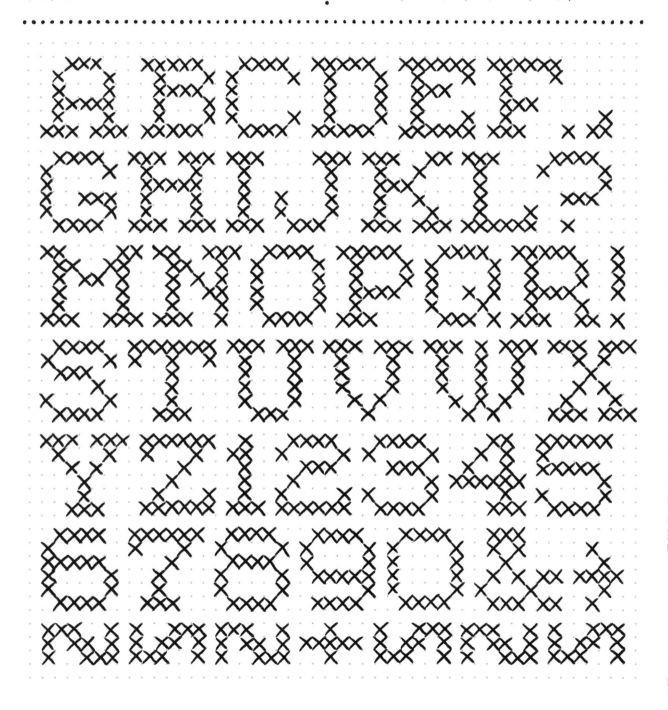

CREATE YOUR OWN CROSS-STITCH SAMPLER HERE: DATE:

HERE ARE SOME SECRET MESSAGES. CAN YOU WORK OUT WHAT THEY SAY?

SOME HAVE PARTS TAKEN AWAY, OTHERS HAVE LETTERS PUSHED TOGETHER.

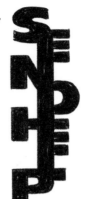

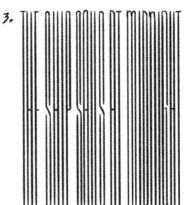

2. SNITCH

3. HE SPEAKS AT MIDNIGHT

1. MEET ME AT THE SECRET CLUBHOUSE

4. THE PASSWORD'S ORANGE BANANA

5. I HAVE CRACKED THE SECRET CODE

6. SEND REINFORCEMENTS FAST

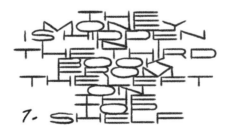

7. THE MONEY IS HIDDEN ON THE THIRD SHELF

8. BEHIND THE THIRD DOOR LIES THE KEY

9. I LIKE STUNT KITES

10. I HAVE CALLED IN SICK BUT I'M REALLY ON HOLIDAY! HAHA

WRITE YOUR OWN SECRET MESSAGES HERE: DATE:

THE BLACKCURRANT JELLY HAS BEEN POISONED

WE HAVE BOOBYTRAPPED THE FRIDGE

THE ZOMBIE APOCALYPSE BEGINS TUESDAY TEATIME

YOUR OWN MESSAGE

YOUR OWN MESSAGE

YOUR OWN MESSAGE

YOUR OWN MESSAGE

YOUR OWN MESSAGE

YOUR OWN MESSAGE

A STRANGE ENCOUNTER WITH A FLYING SAUCER OR A FREAK ACCIDENT INVOLVING RADIOACTIVE WASTE HAS GRANTED YOU POWERS FAR BEYOND THOSE OF MERE MORTAL MEN! YOU DECIDE TO DEDICATE YOUR LIFE TO FIGHTING FOR JUSTICE, RIGHTING WRONGS AND SAVING CATS STUCK IN TREES.

YOUR TAILOR HAS ALREADY RUN UP YOUR STYLISH COSTUME, BUT BEFORE YOU CAN STEP OUT INTO THE DARK LONELY NIGHT, YOU NEED A SUPERHERO EMBLEM! IT COULD BE YOUR HERO'S INITIALS, A SYMBOL THAT DESCRIBES YOUR POWERS — OR EVEN A MYSTERIOUS ALIEN GLYPH OF UNKNOWN MEANING!

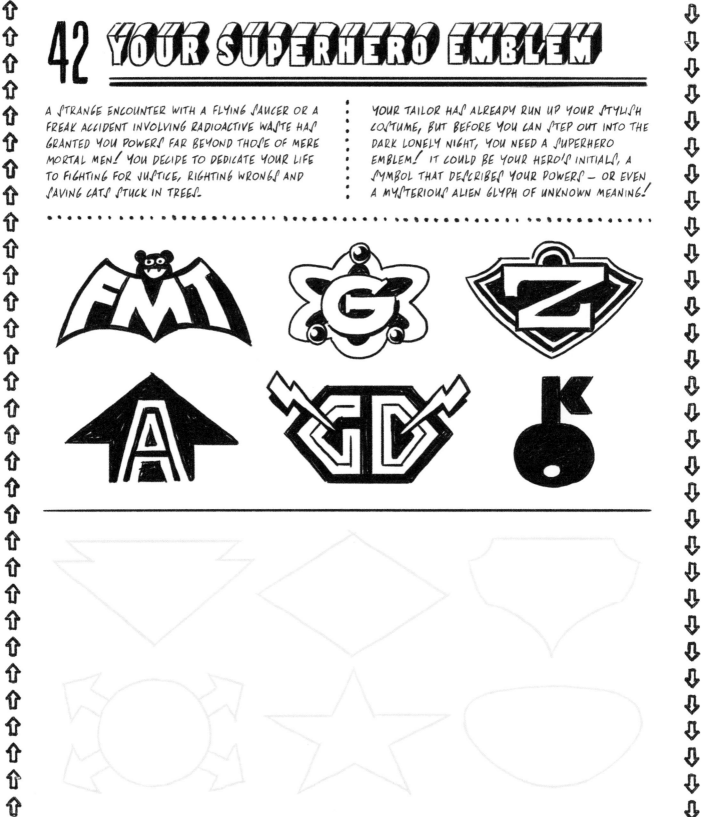

NAME YOUR HERO:

DATE:

NAME YOUR HERO:

DATE:

43 A PHOTO ALPHABET

USING A DIGITAL CAMERA OR A PHONE CAMERA (TRY AND BORROW ONE IF YOU DON'T HAVE ONE) LOOK AROUND YOU AND SEE IF YOU CAN FIND AN EXAMPLE OF EVERY LETTER OF THE ALPHABET!

PRINT THEM OUT ON A PRINTER (AGAIN, TRY AND BORROW ONE IF YOU DON'T HAVE ONE), CUT THEM OUT AND ARRANGE THEM IN ORDER ON THE PAGE OPPOSITE. BELOW ARE EXAMPLES TO GET YOU STARTED.

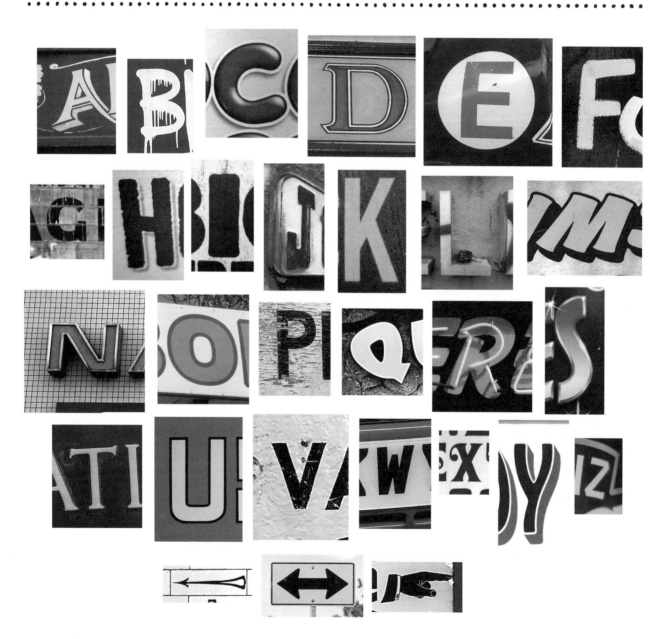

PASTE OR TAPE YOUR ALPHABET HERE: DATE: []

44 DESIGN A SIGN

SIGNS COME IN ALL SHAPES AND SIZES. THEY CAN BE PAINTED ON GLASS OR WOOD, CAST IN METAL OR DRAWN IN CHALK. THEY CAN USE SEVERAL SIZES AND STYLES OF LETTERING MIXED TOGETHER — BIG, SMALL, SERIF, SANS SERIF, UPRIGHT AND ITALIC.

THEY CAN USE LETTERS WITH OUTLINES AND LETTERS WITH SHADOWS, OR LETTERS ON CURVES OR AT ANGLES. IF THE STYLE OF THE LETTERING GETS YOU TO READ THE MESSAGE, THE SIGN HAS SUCCEEDED IN DOING ITS JOB!

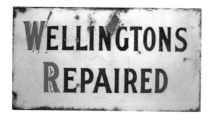

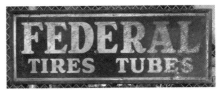

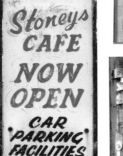

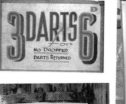

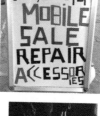

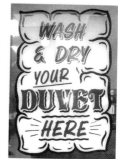

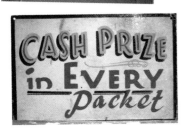

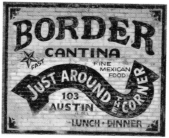

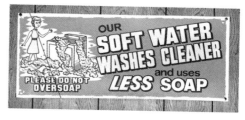

USING THE WORDS WRITTEN BELOW, DESIGN THESE SIGNS: DATE:

FRESH STRAWBERRIES ON SALE

OLD FLIPFLOPS REPAIRED HERE

FINEST QUALITY MANURE FOR SALE
BRING YOUR OWN BAGS

THIS WAY TO SHIPWRECK BEACH

CLOSED FOR TEA FROM 6PM-9PM

SKATEBOARDING COMPULSORY

GIRAFFE ENCLOSURE

WE SELL RED SHIELD MOTOR OIL

QUIET PLEASE - SNOOZING IN PROGRESS

PLEASE DO NOT PERFORM HANDSTANDS ON THE DIVING BOARD

45 THE END

TIME FOR YOUR CURTAIN CALL! HERE IS SOME BEAUTIFUL LETTERING FROM OLD BLACK AND WHITE FILMS.

DRAW YOUR OWN DRAMATIC "THE END" TITLE CARD HERE: DATE: []

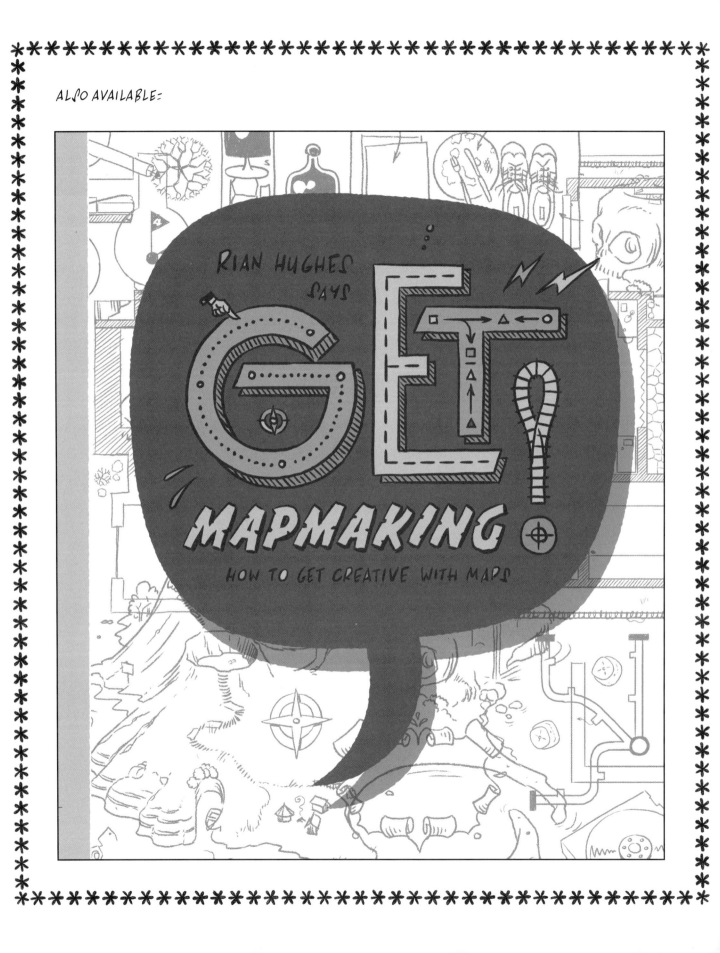